International
Arts and Crafts

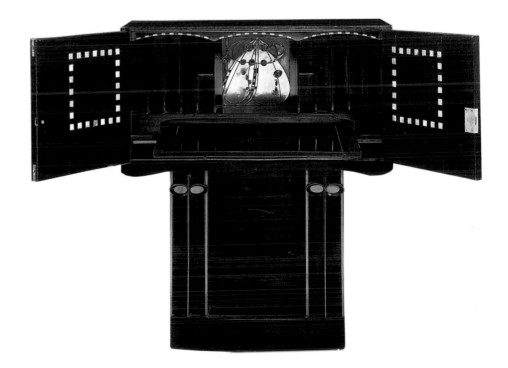

Edited by Karen Livingstone and Linda Parry

International Arts and Crafts

V&A PUBLICATIONS

This book is published to coincide with the exhibition
International Arts and Crafts at the following venues:

Victoria and Albert Museum
17 March – 24 July 2005

Indianapolis Museum of Art
27 September 2005 – 22 January 2006

Fine Arts Museums of San Francisco
de Young
18 March – 18 June 2006

First published by V&A Publications, 2005
V&A Publications
160 Brompton Road
London SW3 1HW

ISBN 1 85177 445 9

A catalogue record for this book is available from the British Library

Printed in Singapore

FRONT COVER ILLUSTRATION: C.R. Ashbee, 'Painters and Stainers'
commemorative cup (see plate 1.11)

BACK COVER ILLUSTRATION: Recreation of a Craftsman room
based on original drawings from Gustav Stickley's Craftsman
Workshops (see plate 11.1)

FRONTISPIECE: Charles Rennie Mackintosh, writing desk.
Ebonised mahogany inlaid with mother of pearl, coloured glass
and leaded glass panel. Britain, 1904. Designed for Walter Blackie
for Hill House, Helensburgh. National Trust for Scotland
and Glasgow Museums and Art Gallery.
© Christies Images Ltd 2005

V&A Publications
160 Brompton Road
London SW3 1HW
www.vam.ac.uk

Contents

Sponsor's Foreword

HEAL'S

Heal's is delighted to support *International Arts and Crafts*

Sir Ambrose Heal, born in 1872, fourth-generation descendant of the founder of the home furnishing firm, was both an inspired shopkeeper and brilliant furniture designer. He embraced the Arts and Crafts Movement, recognising how it could be used to improve everyday design and playing a key role in bringing it to a much wider audience.

We hope that visitors to the exhibition will be inspired by both the creativity of the movement and its exacting standards of good design, quality materials and fine workmanship, values that are just as relevant at Heal's today.

ANDREA WARDEN
CEO HEAL'S

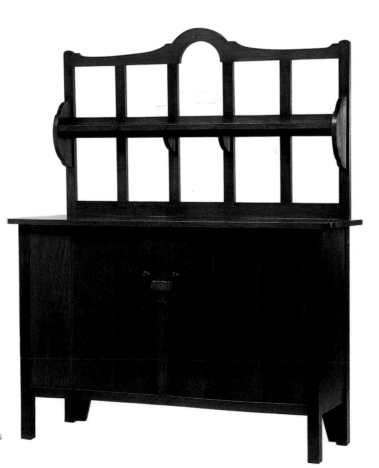

Ambrose Heal, dresser.
Chestnut. Britain, designed
*c.*1904. Made by Heal & Son.
Originally designed for the
'Cheap Cottage' Exhibition at
Letchworth Garden City, 1905.
Collection of The Millinery Works

Director's Foreword

Mark Jones
DIRECTOR OF
THE VICTORIA
AND ALBERT MUSEUM

On 25 April 1910 Walter Crane, President of the Arts and Crafts Exhibition Society, wrote to Sir Cecil Harcourt-Smith, Director of the Victoria and Albert Museum, requesting 'some public and official recognition of the Arts and Crafts Movement of this country, which has had such remarkable effects upon general art-education and public taste of late years.' One way of achieving such recognition, he suggested, was by exhibiting a selection of the 'choicest' Arts and Crafts work at the Victoria and Albert Museum, just as the national museums in Germany and Austria did.

Crane's request was turned down, however, and it was not until 1950 that an Arts and Crafts exhibition was held at the Museum. Fifty-five years later our understanding of the international impact of the Arts and Crafts Movement has changed considerably.

The first movement to be directed at the reform of art at every level, and across a broad social spectrum, Arts and Crafts changed the way we think about design for the home and how we value the way things are made. It represented a moment when British design was widely admired and copied all around the world, as the ideas and principles which shaped the movement were taken up and adapted across America, Europe, Japan and even further afield. The contributions of the many international scholars to this book, and the wealth of material they have drawn upon, reveals not only the importance of the Arts and Crafts Movement in Britain to parallel developments around the world, but also the empathy which resonated across a diverse range of countries and cultures in the quest to find a way of living with tradition while responsibly embracing the future. It was a movement born of ideals, many of which still hold true and travel well today, and it deserves the national study and national recognition that Walter Crane was calling for in 1910.

The exhibition accompanying this book will travel from London to the Indianapolis Museum of Art and the Museum of Fine Arts, San Francisco, both of which will be opening magnificent new buildings in time to host the V&A exhibition. We are delighted to be working with both institutions on this project, and to celebrate the international dimensions of the Arts and Crafts Movement in a country where it was perhaps at its boldest and most successful.

Acknowledgements

The *International Arts and Crafts* exhibition and book was three years in the making could not have happened without the support and contributions of a very large number of people.

Heal's have made the exhibition possible through their generous support and we would especially like to thank them for their involvement. Thank you also to The Huntington Library, Art Collections and Botanical Gardens in San Marino, California, for their award of the Robert R. Wark Fellowship to Karen Livingstone in 2003 to assist with research.

Juliette Hibou, Assistant Curator to the exhibition, has worked extremely hard and patiently to help bring the book and the exhibition to fruition. Many colleagues at the V&A have given help and invaluable advice throughout the project. We would like to thank Frances Collard, Mark Haworth-Booth, Richard Edgcumbe, Anna Jackson, Jennifer Opie, Reino Liefkes, Eleri Lynn, Clare Phillips, Deborah Swallow, Margaret Timmers, Eric Turner, Rowan Watson and Christopher Wilk for all their help and support; and we would particularly like to acknowledge the enormous contribution made by Rupert Faulkner of the Asian Department, who has co-curated the Japanese section of the exhibition, supervised the design and construction of the Japanese model room, and offered help and advice on all aspects of the Japanese loans.

We would like to offer special thanks to all those who contributed sections to this book. Without their help and advice this publication, and the exhibition which it accompanies, could not have achieved such breadth of material and expertise, and we are extremely grateful to all.

The contributing authors themselves would like to acknowledge the many people who have given them help and support. In particular, Martin Barnes would like to gratefully acknowledge Mark Haworth-Booth, Kate Best, Louise Shannon, Charlotte Cotton, Roger Taylor, Brian Liddy, Russell Roberts, Mack Lee, Hans P. Kraus, Rebecca Hable, Carol Campbell, Alan Crawford, Alan Powers, Carol Campbell, Peter Cormack, Violet Hamilton, Polly Fleury, Emma Dennis and Malcolm Daniel. Alan Crawford would like to thank Nicola Gordon Bowe, Annette Carruthers, Ann Compton, Elisabeth Cumming, Peter Cormack, Avril Denton, Richard Edgcumbe, Peter Howell, Cyndy Manton and Joseph Sharples. David Cathers wishes to thank Marilee Meyer, Susan J. Montgomery and Cleota Reed. Denise Hagströmer would like to thank Robert Connolly for his text revision. Cheryl Robertson would like to thank Elizabeth Cromley, Christopher Wilk, Jack Quinan, Bruce Smith, and especially David Schloerb and Kathleen Cummings.

Colleagues from museums, archives and libraries throughout the world have arranged access to their collections, provided information and arranged photography. International scholars, private collectors (some of whom wish to remain anonymous) and advisors have also given their time and support. We are extremely grateful for the assistance of the following people: Tracy Albainy, Victor Arwas, Stefan Asenbaum, Maureen Atrill, Reiner Baarsen, Caroline Bacon, Suzanne Baizerman, Bryce Bannatyne, Bruce Barnes and Joe Cunningham, Helmut Bauer, James Elliott Benjamin, Shelley Bennett, Andrew Bolton, Ted Bosley, Bruce Boucher, Helen Brandon-Jones, Tarald and Elisabeth Brautaset, Antoine Broccardo, John Bryan III, Anna Buruma, Christopher Cardozo, Stephanie Carson, Beth Cathers, Jon and Kate Catleugh, Peter Cormack, Alan Crawford, David Crowley, Elizabeth Cumming, David Park Curry, Mechteld De Bois, George Dalgliesh, Michael Daniel, Lucy Dynevor, Robert Edwards, Martin Ellis, Berit Elvik, Gerda Flöckinger, Mirjam Foot, Alice Cooney Frelinghuysen, Mr T. Figge, Haruhiko Fujita, Eric Jackson-Forsberg, John Jesse, Harvey Jones, Zelina Garland, Mirjam Gelfer-Jørgensen, Tom Gleason, Wolfgang Glüber, Norbert Götz, Ian Gow, Paul Greenhalgh, Mary Greensted, Pippa Hackett, Widar Halen, Shukuko Hamada, Tomoo Hamada, Shinsaku Hamada, Takuji Hamada, Edgar Harden, Barry Harwood, Anne Havinga,

Jan Jaap Heij, Charles Hind, Wendy Hitchmough, Rev.V.W.House, Stephen Jackson, Kagizen Yoshifusa, Kenji Kaneko, Robert Kaplan, Suyako Kawai, Arto Keshishian, Debbye Kirschtel-Taylor, Kunie Kobatake, Michael Koch, Marianne Lamonaca, Boice Lydell, Nancy McClelland, Tommy and Beth Ann McPherson, James and Mary McWilliams, Theo Mance, Philippa Martin, Ryūichi Matsubara, Jennifer Melville, Kyōko Mimura, Jeffrey Montgomery, Masanori Moroyama, Michael Moriarty, Kenichirō Ōhara, Jirō Odani, Jennifer Komar Olivarez, Erna Onstenk, Jesco Oser, Mariko Ozaki, Emese Pásztor, Nicola Redway, Cleota Reed, Paul Reeves, Aileen Reid, Pamela Robertson, Peter Rose, Robert F. Rothschild, Judy Rudoe, David Ryan, James Ryan, Tamae Sagi, Maroun Saloum, Annamarie Sandecki, Ann Scheid, Sarah Schleuning, Kathy Schrader, John S.M. Scott Esq, Chōsuke Serizawa, Ira Simon, Peyton Skipwith, Bruce Smith, Edgar Smith, Janis Staggs-Flinchum, Kevin Stayton, Arlie M. Sulka, Shūji Takashina, Christa C. Thurman, Jessica Todd Smith, Peter Trowles, Isamu Tsujimoto, Kevin Tucker, Kitty Turgeon, Shōzaburō Ueda, Renate Ulmer, Teiko Utsumi, Angela Völker, Martin Williams, Christian Witt-Döring, Mr and Mrs Erving Wolf, Sakiyo Yagi, Shigeo Yamamoto, Sōri Yanagi, Teruo Yasui, Satoshi Yokobori, Shōji Yoshida, Ayumi Yoshikawa, Ghenete Zelleke.

The reconstruction of the Craftsman room in the exhibition was undertaken with the special contributions of a number of people, to whom we are deeply grateful for everything they have done to help us on this and other aspects of the exhibition. Particular thanks are due to Jo Hormuth, whose experience, knowledge and design skills allowed us to create the room. Thank you also to Tim Gleason for the enormous amount of advice and help he has given. And we are extremely grateful to Jan Toftey and to Mr John H. Bryan for their trust and support.

The reconstruction of the Japanese room in the exhibition has been made possible through the efforts of a large number of people. We are particularly indebted to our consultant in Japan, Tomoo Kawashima; to Haruko Ochiai and Shigeyuki Yoshioka at the Asahi Beer Ōyamazaki Villa Museum, Kyoto; and to Taneo Katō and Tamehisa Yamamoto of the Asahi Beer Arts Foundation, Tokyo. We are also grateful to Fushimi Kōgei Co. Ltd of Kyoto for their skilful realisation of our plans.

Large projects such as this rely on the contribution of volunteers and temporary staff, who provide invaluable assistance with research and administration. We would particularly like to thank Sonja Arbogast, Sally Cross, Francisco Ferreira, Roxanne Peters, Helen Searing and Michelle Watkiss for giving their time and help so willingly to this project.

Special thanks are due to the V&A Publications team; in particular Mary Butler, Ariane Bankes, Frances Ambler, Monica Woods, Claire Sawford and Victoria Standing, and to Colin Grant for his careful editing; to Harry Green for the elegant book design and to W. Glyn Jones, Janey Tucker and Kyōko Andō for their translations. Thank you also to Christine Smith of the V&A Photographic Studio for the consistently high standard of new photography which has helped bring a fresh view to familiar objects, and to Ken Jackson for accommodating all our requests.

From the V&A departments of Exhibitions, Press, Marketing, Design, Development and Research many thanks are due to Linda Lloyd Jones, Jane Drew, Eleanor Townsend, Elizabeth Morgan, Ann Hayhoe, Debra Isaac, Patricia O'Connor, Helen Beeckmans, Jane Rosier, Greg Hall, Moira Gemmil, Faye Rogers, Robert Kester, Nicole Newman, Laura Hingley, Carolyn Sargenston, Christopher Breward, Amin Jaffer, Jane Pavitt and Ghislaine Wood. All have been a tremendous support.

Thank you to Allies and Morrison for their responsive exhibition design, and to Fraser Randall for project managing the exhibition design and installation; thankyou also to Nick Wood for his wonderfully revealing photographic studies of architecture and interiors for the exhibition; and to Edward King at Blackwell and Ritva Ware at Hvitträsk — we are most grateful to you for allowing us such unfettered access to the properties you care for.

KAREN LIVINGSTONE
LINDA PARRY

1

Introduction: International Arts and Crafts

**Linda Parry and
Karen Livingstone**

Arts and Crafts

Arts and Crafts was an international movement that flourished in Britain, Europe and America from the 1880s until the First World War, and in Japan from the 1920s until the Second World War. It has been referred to as the first truly modern artistic movement. Developed initially in Britain, it had a widespread influence. It was originally based on an idealistic set of principles for living and working, which were taken up and adapted in many parts of the world to meet specific social and national needs, integrating heritage, local skills and resources.

Many of the characteristics of the movement can still be detected in the decorative arts today: the importance and benefit of practical skills in which individual production and small workshop practice are valued above mass manufacture, for instance. Also inherited directly from the Arts and Crafts Movement was an improvement in domestic design brought about through a new attitude towards living in which items were made to match their purpose and also harmonize together in an interior to provide a total work of art, or *Gesamtkunstwerk*, a German term now used widely (plates 1.1, 1.2). This balancing of design and technique was quite alien in mid-nineteenth-century production when the search for new technology ensured that technique, in the form of novelty of effect, speed and cheapness of production, dominated. But it is perhaps in the advocacy of simplicity in design and manufacture, a need to allow the quality of materials to speak for themselves, that the Arts and Crafts Movement has had its greatest influence on the arts today. Whereas simplicity is a major characteristic of the movement, its foundations and development — a combination of the ideas and aspirations of many over a period of twenty-five years — were complex. Before tracing this in greater detail it is important to attempt to define the term 'Arts and Crafts'.

Today, Arts and Crafts describes the process of hand-making or decorating objects (also frequently referred to as 'craftwork') on a semi- or completely amateur basis.[1]

The Arts and Crafts Movement of the late nineteenth and early twentieth century was different. Far more professionally and commercially based, it took its name from the Arts and Crafts Exhibition Society, which was founded in London 1887, and staged its exhibitions at the New Gallery, Regent Street, from 1888 (plate 1.3; see chapter 2). Subsequently, the movement encompassed international groups who frequently adopted the British term of Arts and Crafts for their societies,[2] studios, workshops and even a shop.[3] However, the movement also included a number of developments in different parts of the world with names or descriptions more appropriate for their own work, as will be described in the following chapters. What bound them together was a unity of ideas that influenced their work, even though the work is often visually quite different. All sought a great improvement in the arts through the adoption of a new democratic ethic towards living and working. In some areas this was brought on by a need for social, political and cultural change, whereas elsewhere it simply provided a means of reforming industry and improving everyday design. This was unlike any other artistic movement that had gone before.

Many parts of Europe were in political and social turmoil in the late nineteenth century. Some countries, which had been ruled for centuries from outside their lands yearned for autonomy or at least some measure of independence. Other countries wished to escape from injustices and inhumanity, as they saw it, brought on by their own highly developed and complex industrial societies. The arts provided a fertile ground in which traditional ideas could be challenged, and this developed in a number of ways. Writers and genre artists had led the way from the middle of the century with calls to improve society through their own personal representations of class inequality and poverty. Music and the decorative arts followed, providing on the one hand a strong sense of national unity and on the other a means of improving day-to-day life through the design, manufacture and use of domestic items. Nothing was too small

1.1 M.H. Baillie Scott, window. Leaded stained glass. Britain, 1902. For the music room of Dr R. K., Mannheim, Germany. Museum Künstlerkolonie, Darmstadt

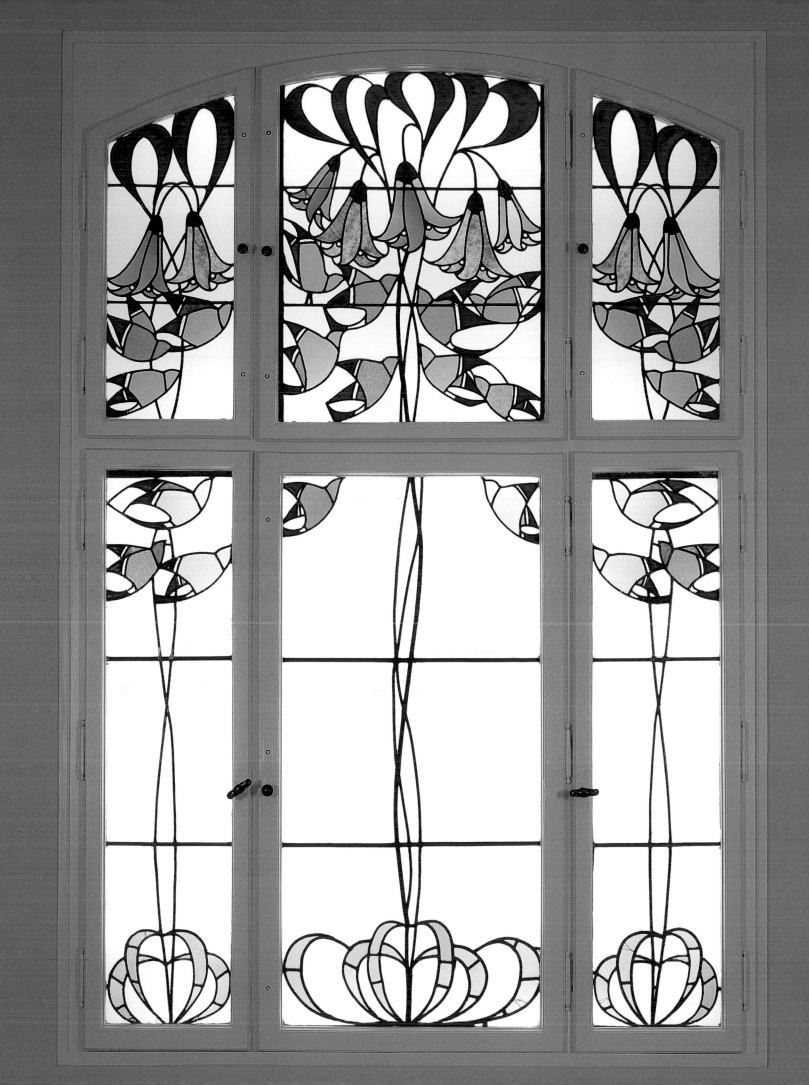

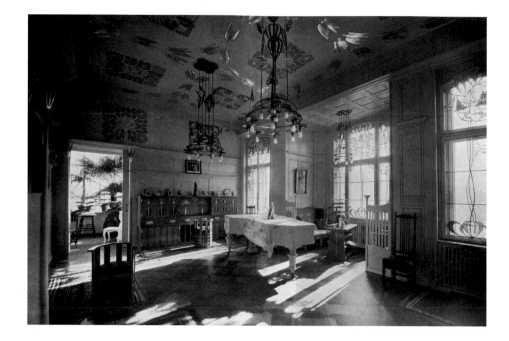

1.2 M.H. Baillie Scott, music room of Dr R. K., Mannheim, Germany. *Innen Dekoration*, July 1902.

or insignificant to be carefully designed and lovingly made in the workshop or studio (plate 1.4).

Critics not directly involved in the Arts and Crafts Movement made no division between this and other contemporary artistic developments. This led to a confusion in particular between Arts and Crafts and Art Nouveau, the other major European development that occurred at the end of the nineteenth century. The two movements were often seen as one. This situation has proliferated to the present day. Both distinct groups of artists and designers submitted work to international exhibitions,[4] and their work was sold together in many of the most fashionable European shops.[5] The work was often jointly described as the 'new art'. This was particularly true of trade papers such as the British *Furniture Record* and *The Furnisher*, which were more used to considering work within a strict commercial framework, rather than comparing styles and philosophical make-up.[6] Both movements qualified for the description of 'new art', but straight translations of foreign journals have led to some developments of the Arts and Crafts Movement being classed specifically as Art Nouveau.

Yet the two movements were so different that they can be described as the antithesis of each other. This can be explained by comparing geographical spread, by the physical and aesthetic nature of the work produced and by the contrasting ideas behind each movement. Art Nouveau was born and moulded in France and Belgium,

with separate developments in cities in central and southern Europe. It appealed to romantic and exotic tastes in particular and was cosmopolitan, sophisticated, pleasure-loving and extravagant in its aims. It was also deeply personal, 'an art of individuals and coteries' according to one American critic.[7]

Based specifically on the premise that art could and should exist for its own sake, Art Nouveau sought to evolve a new style by both shocking and luring its audiences at the same time. It looked at new ways to express emotion, and the sensuality of much of its subject matter helped achieve this. Nature was a major source of inspiration but plants were manipulated and stylized to produce symbolic imagery rather than horticultural accuracy. Always luxurious and sumptuous in the range of materials used in the manufacture of furnishings, applied surface decoration was an essential part of the final dramatic effect that was sought. This was provided by veneers and marquetry on furniture; engraving and opalescence in glass; burnished gold, enamelling and precious gems in jewellery; and brocading and watering on silks. This detailed and complex work required the most advanced, up-to-date technical equipment and skills. It was the finished product rather than the process of making that was important. At its best Art Nouveau was one of the most accomplished, arresting and original artistic movements seen in Europe. At its worst it was self-indulgent, decadent and superficial, keeping alive traditions and hierarchies of manufacture that pandered to technology rather than individual skills. However, the ambitions of many Art Nouveau designers, seeking new expression of beauty and emotion, were modest when compared with the mission-like zeal of many pioneers of the Arts and Crafts Movement who strove to change the world.

The artists, architects, designers and craftworkers of the original London Arts and Crafts Exhibition Society were altogether more puritanical in their aims and prose-lytizing in their manner. They followed the well-trodden path in demanding an improvement in the design and manufacture of the decorative arts in Victorian Britain first initiated by Henry Cole in the 1850s (see chapter 2). The following thirty years had seen great improvements in the design of goods but no fundamental change in manufacture. Arts and Crafts members analysed the state of industry. They claimed that improvement in the

decorative arts was only possible through a radical change both in the way things were made and how the products of industry were perceived. The decorative arts had been of minor importance for many generations. By elevating the status of the craft and by changing the very basis of production in Britain, improvement would follow. They advocated turning away from manufacturing processes and practices, many of which had been in continuous use since the late eighteenth century. From these had devel-

oped large-scale factories that had destroyed communities and the lives of those who worked in them, and had led to degenerate art. They felt that commercial success was possible through other means. The main strength of their argument came from the fact that these changes had been tried and achieved successfully by William Morris (1834–96), who by 1887 was an internationally renowned and commercially successful designer and manufacturer. In fact Morris had evolved his work practices

1.3 The third exhibition of the Arts and Crafts Exhibition Society, New Gallery, Regent Street, London, 1890.

1.4 C.R. Ashbee, salt cellar. Silver, parcel gilt, with cast, chased and applied decoration set with carnelians. Britain, 1899–1900. V&A: Circ.58-1959

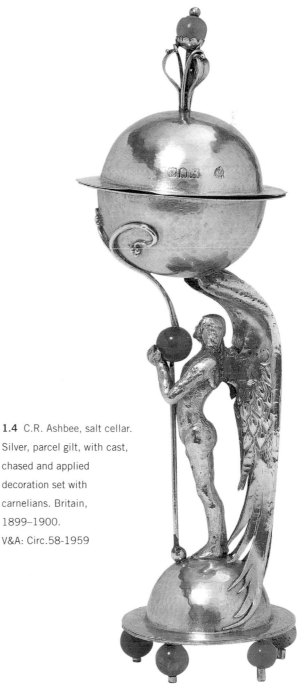

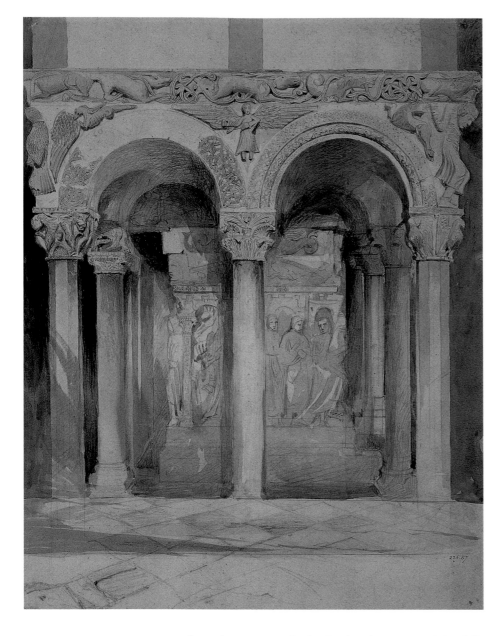

1.5 John Ruskin, *The Pulpit of San Ambrogio*. Watercolour on paper. Britain, *c*.1845. V&A: 226-1887

the Arts and Crafts Movement, relearned the value and importance of individual artistic skills. But this was not the case in mid-nineteenth-century industrial Britain where the constant search for technological developments had affected every aspect of design and manufacture. Ruskin's words were a shining beacon of sense to an audience demoralized by the powers of increasing industrialization. What is more difficult to understand is how his ideas had a resonance for those living in different rural and agrarian communities not yet part of the industrial world.

For many years Ruskin had made a detailed study of ancient buildings and his views came directly from the pleasure he derived from them. His travels concentrated on the sophisticated cities of Europe, yet his emotional and aesthetic reactions to why they were so successful were primeval in their simplicity. His study was intense and personal. As a very competent draughtsman, he produced many drawings and watercolours of the buildings that he most admired, yet in the end his words proved to have the greatest influence (plate 1.5).

Although Ruskin returns to a similar theme in later publications, *The Stones of Venice* (1851–3) had the greatest impact on Morris and many of his contemporaries. In 'The Nature of Gothic', the central chapter of volume II, Ruskin simply and eloquently described the reasons why European medieval art ('not that of Venice only, but of universal Gothic') was so admirable. There were two main thrusts to his argument in which he explains why it had happened and what changes should be made to create a similar situation in mid-Victorian England. Medieval art, he explained, was made by ordinary men who were masters of their own work and not slaves either to machinery or each other. Their art was full of imperfections but honest and thoughtful: 'smile … at the fantastic ignorance of old sculptors – ugly goblins, formless monsters but do not mock them, for they are signs of the life and liberty of every workman', and all the more beautiful because of this. They possessed 'a freedom of thought, and rank in scale of being such as no laws, no charters, no charities can secure'.

He believed that this ideal artistic environment, which relied on co-operation rather than competition, could only be achieved in Victorian Britain through:

a right understanding, on the part of all classes, of what kinds of labour are good for men, raising

from the writings of John Ruskin (1819–1900) by fully enunciating in practical terms Ruskin's moral philosophy on the nobility of craftsmanship. It is appropriate here to attempt to explain what Morris gained from Ruskin and how this became the creed for the early movement in Britain, America, Europe and Japan.

Ruskin

The towering influence of Ruskin on the national and international Arts and Crafts Movement has always been widely acknowledged. His views today appear simplistic to an audience that has, thanks to the advent of

them, and making them happy; [and] by a determined sacrifice of such convenience, or beauty, or cheapness as is to be got only by the degradation of the workman; and by an equally determined demand for the products and results of healthy and ennobling labour.

On the practice of the division of labour, a particular bone of contention throughout the industrial world in which production was split in to many different component parts with each done by different people, he was particularly scathing, stating 'it is not the labour which is divided but the men'.

William Morris

Many read Ruskin's advice and were immediately struck by its intelligence. Much of Morris's future career as a designer, manufacturer and political activist was moulded by this single chapter which, when he first read it 'seemed to point out a new road on which to travel'.[8] As time went by, his personal interpretation became more politically charged than Ruskin had ever intended.[9] If anything, Ruskin preferred paternalism and a clearly defined social hierarchy to political upheaval, although he once claimed to have been a communist until he saw what the revolutionary mob had done to the Hôtel de Ville in Paris. Despite this, it was through Ruskin that Morris later claimed 'that I learned to give form to my discontent, which I must say was not by any means vague. Apart from the desire to produce beautiful things, the leading passion of my life had been and is hatred of modern civilisation.'[10]

In his own workshops Morris relied on the practical skills of his staff, on the natural beauty of the materials and the joy inherent in craftsmanship to provide the results he desired. He trained his workers in the long-forgotten or recently abandoned methods of manufacture, such as natural dyeing and hand block-printing (plate 1.6), but also in grander historical techniques, such as tapestry weaving, which he believed to be one of the great art forms (plate 1.7). He had faith in their abilities but did not take them for granted. Further

1.6 William Morris, *Tulip and Willow*, furnishing fabric. Block-printed and indigo-discharged cotton. Britain, designed in 1873. Made by Morris & Co. V&A: Circ.91-1933

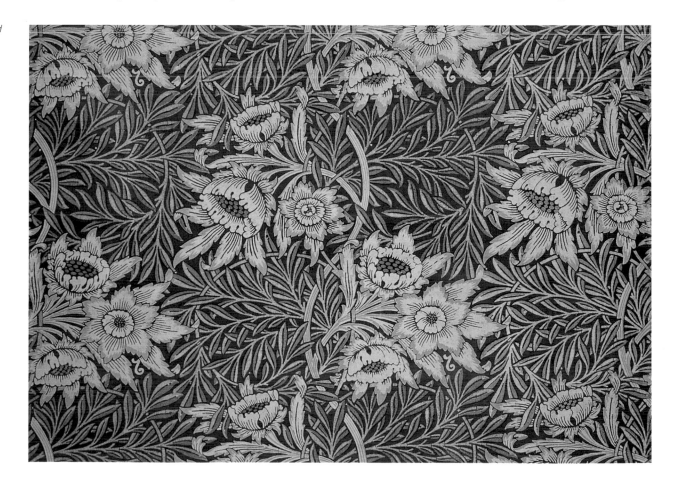

The beasts that br in wood and waste

1.7 William Morris, John
Henry Dearle and Philip
Webb, *The Forest*, tapestry.
Woven silk and wool. Britain,
1887. Made by Morris & Co.
V&A: T.111-1926

developing Ruskin's view that happy workers produced beautiful work, he attempted to increase their enjoyment (and productivity) by ensuring not only that they took pride in their work by being fully involved and taking responsibility for all stages of production but also that they had a pleasant working environment. This was fully explained in his 1884 lecture 'How We Live and How We Might Live':

> The last claim I make for my work is that the places I worked in, factories or workshops, should be pleasant, just as the fields where our most necessary work is done are pleasant. Believe me there is nothing in the world to prevent this being done, save the necessity of making profits on all wares; in other words, the wares are cheapened at the expense of the people being forced to work in crowded, unwholesome, squalid, noisy dens: that is to say, they are cheapened at the expense of the workman's life.[11]

These ideas caught on and were developed over the next twenty years, even inspiring numerous attempts to transport industry directly to the countryside (see chapters 3 and 4).[12]

By 1874 Ruskin had already become concerned by the way his views had been generally misunderstood and misused. Acknowledging that no publication of his had

had so much influence on contemporary art as *The Stones of Venice*, he regretted that this only applied to the third section, that which compared and recommended specific historical styles and the use of colour in architecture. He felt that his main moral message had not been fully absorbed.[13] However, he saw in Morris a true advocate. In a letter of 3 December 1878 Ruskin acknowledged that he was 'the only person who went straight to the accurate point of the craftsman's question'. This letter is particularly significant, for Ruskin also suggested that these ideas should have a wider audience: 'How much good might be done by the establishment of an exhibition anywhere, in which the Right doing, instead of the Clever doing, of all that men know how to do, should be the test of acceptance.'[14]

This would appear to be the first suggestion to display work based on new ideas. Nothing tangible was to come of it for a further ten years. Even then Morris was not party to any of the early meetings in the following decade that eventually resulted in the foundation of the Arts and Crafts Exhibition Society, despite him being a major influence on how and why it was set up. On the contrary, at first he doubted its chances of success. On 31 December 1887 he wrote an uncharacteristically negative letter to one of the organizers:

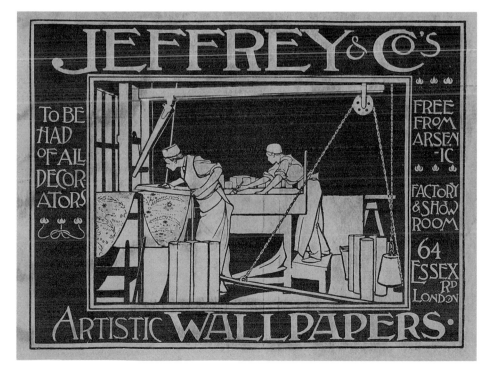

1.8 Jeffrey & Co., letterhead.
Woodblock print, ink on paper. Britain, 1899.
V&A: F.42A/2-1945

One thing will have to be made clear i.e. who is to find the money. I can't help thinking on reflection that some money will have to be dropped upon it: for I don't think … that you will find commercial exhibitors willing to pay rent for space, and the shillings at the door will not, I fear, come to much after the first week or two: the general public don't care one damn about the arts and crafts; and our customers can come to shops to look at our kind of goods; and the other kind of exhibits would be some of Walter Crane's work and one or two of Burne-Jones: those would be the things worth looking at; the rest would tend to be of an amateurish nature, I fear. In short, at the risk of being considered a wet blanket, a Job, or Job's comforter, and all that sort of thing, I must say I rather dread the said exhibition: this is of course my private view of the matter, and also of course I wish it success if it comes off.[15]

Morris's doubts were ill founded and the first exhibition was a great success. Despite his early reservations he became a member of the Society and was appointed to the committee from its inauguration in 1888. In 1891 he was elected president, a post he held until his death in 1896.

The influence of the British Arts and Crafts Movement

But how did the British movement influence the setting up and development of similar groups abroad? Ruskin and Morris are always quoted as providing the inspiration behind the movement but their influence was far less tangible outside Britain. It is true to say that their written work was widely read but more for its moral, philosophical and, in the case of Morris's lectures and prose romances, political content than as a set of rules to follow. By 1890 there were more practical interpretations of these ideas in Britain. Chief among these were new workshops started by individuals and groups of craftworkers keen to make their own designs. But production did not rely exclusively on hand craftsmanship, contrary to the views of many commentators. In fact in the early years of the movement many followers were equally receptive to a careful and controlled use of the machine, as Frank Lloyd Wright (1867–1959) in America and the Deutsche Werkbund in Germany were later to advocate. A few established companies, situated

in parts of the country suited to their particular form of textile, ceramics, stained-glass or wallpaper production, set up specialist experimental studios to revive an interest in their own wares and compete in the new markets (plate 1.8). The most successful samples made were then put into limited production and sold commercially. At the same time a number of new firms were established that integrated hand and small-scale machine production. Initially, textile manufacturers took the lead in this new industrial atmosphere inspired by and often replicating the types of production so successfully carried out at Morris's Merton Abbey Works near Wimbledon, south London.[16] The machines they used were jacquard-weaving looms in which the threads were inserted into the loom by hand or, in the case of large orders, by steam-power. There was limited production by power, and ironically this was often completed by a large commercial sub-contractor, many of whom had factories in Lancashire and Yorkshire with the working conditions now so fiercely condemned. However, this did not mean that the textiles were not Arts and Crafts in spirit or conception.

These various forms of enlightened production that utilized both old and new techniques and practices were widely adopted and in time were used both in workshop and small factory production. By the turn of the century British Arts and Crafts proponents were responsible for a wider and more comprehensive range of decorative arts (furniture, ceramics, wallpapers, glass, textiles, carpets, metalwork and jewellery), all worked under more similar conditions than had been witnessed in the country before (plates 1.9–1.15).

Education became an important vehicle with which to spread Arts and Crafts ideas and to teach specific skills. Regional art schools in England, Scotland and Ireland all developed thriving classes devoted to the training of professional designers and crafts workers. Women as well as men took part and new workshops taught skills such as metalwork of all kinds (brass and copper work, wrought iron, enamelling and jewellery), embroidery,

1.9 Charles Harrison Townsend, *Omar*, furnishing fabric.
Jacquard-woven wool and cotton. Britain, 1896–1900.
Made by Alexander Morton & Co.
V&A: Circ.887-1967

book-binding, graphic arts and stained glass, to name just a few. In 1896 the Central School of Art and Crafts was opened in Holborn in London, specifically devoted to the proliferation of Arts and Crafts ideals under the inspired leadership of W.R. Lethaby (1857–1931), its part-time co-director from 1896 to 1902 and principal until 1911. Art colleges all submitted examination work through a national system centred on the School of Art,[17] which was attached to the South Kensington Museum (now the Victoria and Albert Museum).

London Arts and Crafts exhibitions also exhibited work produced through less formal evening and day classes and small workshops set up mostly in rural areas throughout Britain. Intended for both amateurs and those needing employment, these groups such as Langdale linen in the Lake District, Newlyn copper in Cornwall, and Limerick lace and Donegal carpets from Ireland utilized local skills and resources. A few of these

1.10 C.F.A. Voysey, table. Oak, originally unpolished and unstained (dark varnish a later addition). Britain, designed in 1903, made in 1905–6 by F.C. Nielsen. For Hollymount, Buckinghamshire, the home of C.T. Burke. V&A: W.19-1981

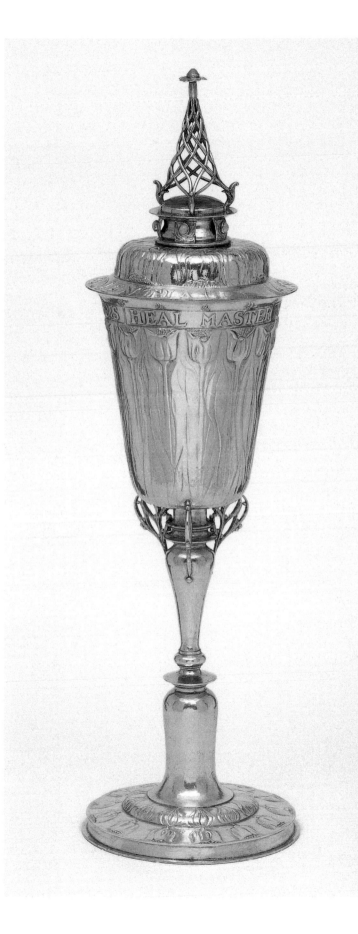

1.11 C.R. Ashbee, 'Painters and Stainers', commemorative cup. Silver, set with semi-precious stones and enamelled decoration. Britain, 1900–1901. Made by W. Poyser, London. Commissioned by Harris Heal to commemorate his term of office as Master of the Painters and Stainers Company. V&A: M.106-1966

projects were successful in attracting the attention of fashionable city shops, whereas others produced no more than a short period of employment and respite from poverty. More often than not the good intentions and enthusiasm of the many philanthropists who set up these groups were not matched by their business acumen.

Apart from groups established in rural areas where skills or a history of traditional production existed, the call of the countryside was so strong that a number of businesses moved away from the cities, despite the increased difficulties of attracting commercial attention. It is interesting to note that, although the work was more fulfilling and the environment peaceful and healthy, the balance of power in manufacture had stayed much the same, notwithstanding the well-meaning intentions of those involved. It was now a socially aware middle class rather than profit-inspired capitalists who persuaded their poorer countrymen to work for them.

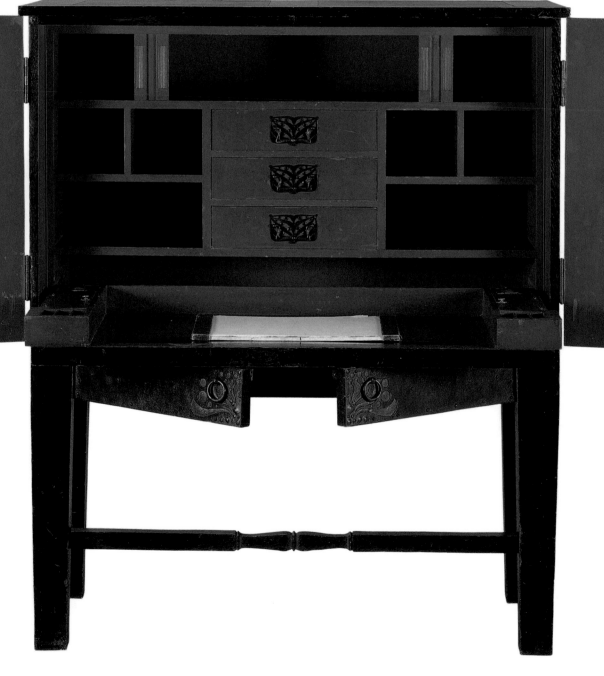

1.12 C.R. Ashbee, 'Lovelace' escritoire. Oak outside, stained dark green, with interior of painted poplar and pierced wrought-iron hinges backed with morocco leather. Britain, c.1900. Made by the Guild of Handicraft, with interior painting designed by C.F.A. Voysey. Made for Mary, Lady Lovelace. Private collection

1.13 Charles Rennie
Mackintosh, hall chair. Oak,
stained dark with rush seat.
Britain, 1901. For Windyhill,
Kilmacolm. Hunterian Art
Gallery, University of Glasgow

1.14 C.F.A. Voysey, clock.
Mahogany, painted and
gilded, brass and steel.
Britain, 1895 6. Case
made by Frederick Coote.
Movement made by Camerer,
Cuss and Co.
V&A: W.5-1998

Early developments abroad

All these various Arts and Crafts activities proved fascinating for the critics, theorists, political activists, architects, artists and designers from abroad who visited the towns and countryside of Britain or saw British work exhibited at various international exhibitions. Many wrote of their experiences and differing attitudes towards British production. For those not able or interested in travelling to Britain, a number of widely circulated European magazines covered a great deal of British work. Among the most widely read were *The Studio*, which was published in London and

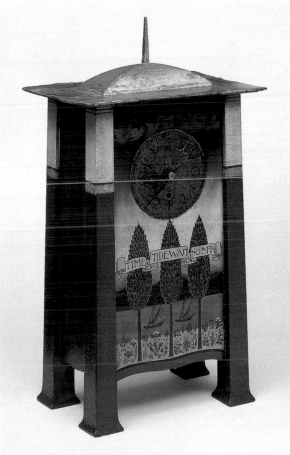

also had a widely distributed international version; the French *Art et Décoration*; the German *Moderne Stil*, and *Dekorative Kunst*, and the Austrian *Kunst und Kunsthandwerk*. In 1901 the first issue of Gustav Stickley's *The Craftsman* magazine was published and, although primarily devoted to the American Arts and Crafts Movement, also included extensive cover of develop-

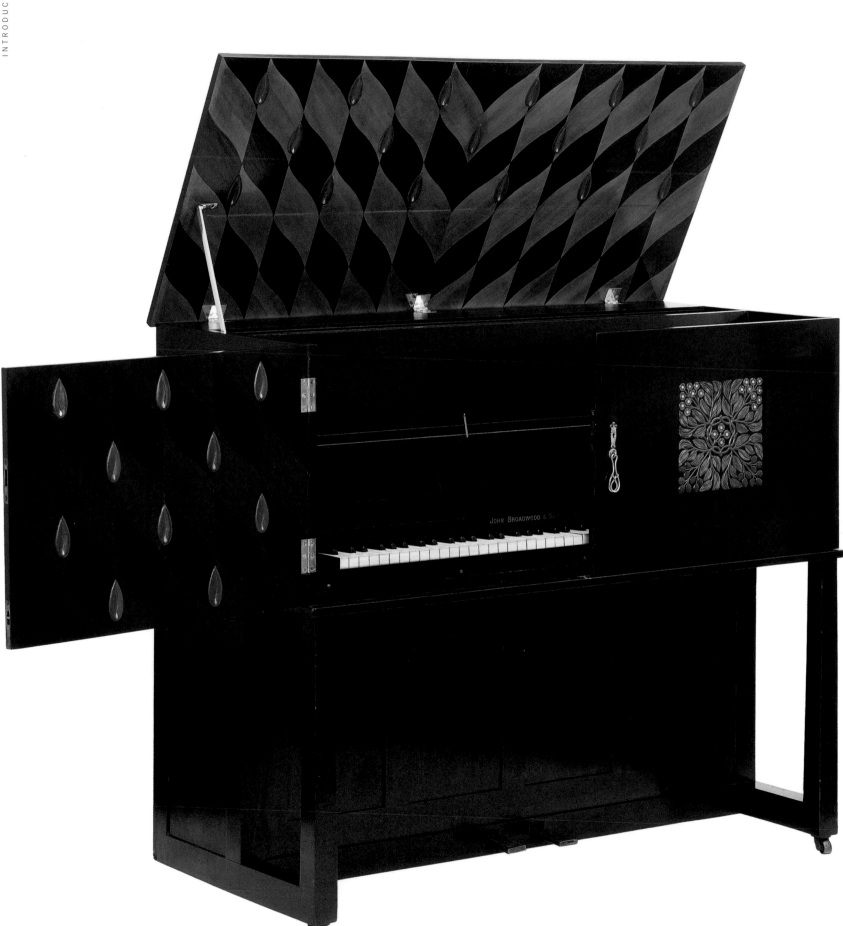

1.15 M.H. Baillie Scott,
'Manxman' piano. Ebonized
mahogany, carved wood,
pewter, mother of pearl,
marquetry of stained woods,
silver-plated handles and
hinges. Britain, designed
in 1896, made in 1902–3.
Movement made by John
Broadwood & Sons Ltd.,
London, case possibly
by Broadwood, the Guild
of Handicraft or the Pyghtle
Works.
V&A: W.15-1976

ments abroad. Through the pages of these magazines the work of a number of British designers, chiefly Walter Crane (1845–1915), C.F.A. Voysey (1857–1941), C.R. Ashbee (1863–1942), M.H. Baillie Scott (1865–1945) and C.R. Mackintosh (1868–1928), became well known.

British Arts and Crafts designers also travelled abroad, lecturing and attending exhibitions in which many had also taken part. Crane, Ashbee and Mackintosh were frequent visitors to many parts of Europe and America, and commissions undertaken by architects such as Edwin Lutyens (1869–1944) and Baillie Scott further widened a knowledge of their work and increased their influence outside Britain. It is this second generation of designers rather than Ruskin and Morris that are today seen as being the greatest influence on the contemporaneous movements in America and Europe.

American developments

American Arts and Crafts was as diverse in style as it was in Britain but, as a separate development, proved more successful in absorbing the fundamental characteristics of the movement and integrating these into commercial practice. Through the contribution of innovative and influential exponents such as Frank

Lloyd Wright the movement showed continuous progression in the design of houses and their interiors from the 1890s until the second half of the twentieth century. Examples of modestly furnished Arts and Crafts houses were advertised in *The Craftsman* magazine and these provided a popular early national style (plate 1.16). On a more exclusive level 'bespoke' was available through the work of a growing range of talented architects. Both embraced the Arts and Crafts ethos of the completely coordinated home in which all aspects of the building, its exterior and interior design, fittings, furnishings and gardens, were all created as one. This was a concept eagerly accepted by American clients who could afford it, and a number of the best examples of commissions by Greene and Greene and Frank Lloyd Wright have survived with much of their detailing intact to this day. Sadly, a similar holistic approach was not so successful in Britain where clients were less happy to have their interior furnishings dictated by their architect, preferring a mixture of more traditional ideas alongside the new.

There are a number of reasons why Arts and Crafts ideas were more roundly embraced in America than in Britain. The United States of America was just a hundred and ten years old and only thirty years had passed since the destruction of the Civil War when the first Arts and Crafts exhibition opened in London. It was a new country but already a burgeoning industrial force through the keen commercial awareness and entrepreneurial skills of both first and second generations of immigrant businessmen. The influx of immigrants from Europe throughout the nineteenth century had provided a wide range of skilled and semi-skilled labour. Many workers found employment in large factories set up in areas of the East and Midwest that had developed from rural to industrial economies in a moderately short space of time. But there were also modest manufacturing companies set up around workshops in many parts of the country for the production of artistic items for the home, including furniture and metalwork. A number of these were started by European emigrants as an outlet for the skills they had brought with them. Consequently, small-scale manufacture producing handmade goods was more familiar to American craftsmen than to their British counterparts.

1.16 Gustav Stickley,
'bungalow' settle. Oak,
leather. America, *c.*1901.
Made at the Craftsman
Workshops, Syracuse,
New York.
Private collection

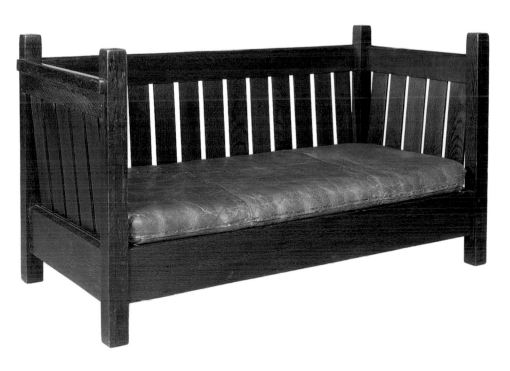

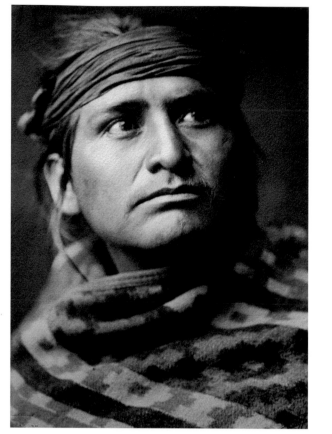

1.17 Edward S. Curtis,
Chief of the Desert – Navaho.
Warm-toned platinum print on
textured paper. America, 1904.
Collection of
Christopher Cardozo

Despite this, no separate recognizable national design vocabulary existed in America apart from simplified versions of fashionable European styles. In an attempt to replicate the work of the most commercially successful continental makers, many mid-nineteenth-century American manufacturers – furniture, ceramics, glass – produced work based on a mixture of historical and geographical sources. The need to discover a national style, the benefits of wide-ranging skills from a multinational workforce and the confidence gained from living in a young, hard-working, enthusiastic and progressive country stimulated the birth of the American Arts and Crafts Movement. But where did the main influences come from?

During the decades following the Civil War many Americans were forced to take stock of their lives. The search for a harmonious future led to an increasing awareness of an indigenous past that they had had little time to notice during their own development. They already loved the land they had inherited, and during the last two decades of the nineteenth century they developed an increasing fascination for the lifestyles of indigenous Americans (plate 1.17). Traditional crafts by

1.18 Second phase Chief's
blanket. Ravelled *bayeta*
(baize) and handspun wool.
America, 1860–65.
Private collection

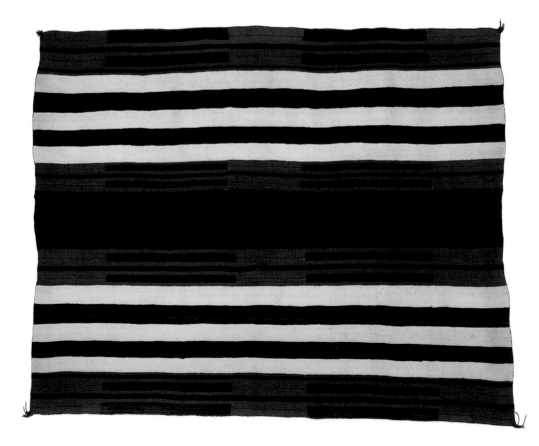

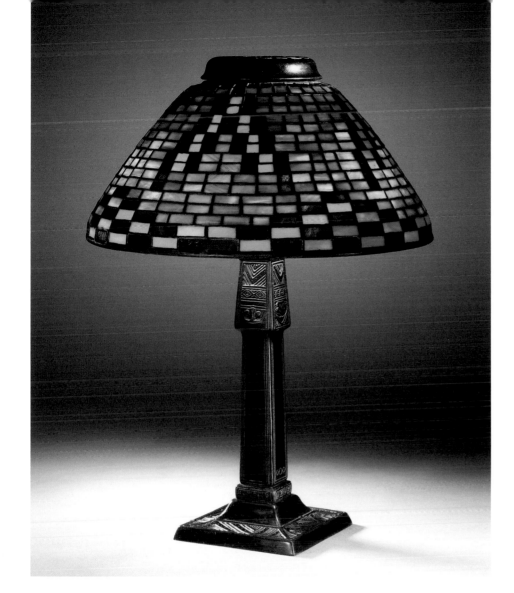

1.19 Tiffany Studios, 'American Indian' lamp. Leaded glass, bronze. America, 1910. Private collection

mending them to clients including John and Frances Glessner for whom he designed a house in Chicago in 1885, a year before his death. In later years these furnishings sat comfortably with American Arts and Crafts objects also commissioned for the house by Mrs Glessner, who was herself an accomplished metalworker.

More frequent visits by American followers of the Arts and Crafts Movement took place in the 1890s. Elbert Hubbard, Arthur and Lucia Mathews and Gustav Stickley made comparatively short trips to London in order to visit designers, workshops and fashionable West End stores such as Liberty's, Heal's, J.S. Henry and Morris & Co. Stickley took a special interest in particular ranges of metalwork, inlaid furniture and appliqué embroidery, all of which were to influence goods produced by his own company (see chapter 11).

Other American visitors stayed longer but surviving reports do not suggest any specific visits to any of the London Arts and Crafts exhibitions. Many knew of the major artistic developments in Britain through word of mouth or published sources and arranged their visits to experience events that interested them most. In London Ellen Gates Starr took bookbinding lessons from Thomas Cobden-Sanderson to prepare herself to teach the subject at Hull House, Chicago, and Celia Fox, the assistant of West Coast architect Samuel Maclure, worked under Voysey for two years. In 1902 the writer Jack London spent time at Ashbee's Guild of Handicrafts in Chipping Campden, wishing to observe, at first hand, the practical and political manifestations of Ruskin's writings, of which he was a great admirer.[19]

The progress of the movement through specific areas of America is mapped out in chapters 11, 12 and 14. These show that the adoption of Arts and Crafts ideas during a less political yet more commercially aware period than existed in Britain provided a springboard for success and a model for the future. However, there were exceptions, especially the idealistic experiments for communal living such as Elbert Hubbard's Roycroft, Gustav Stickley's Craftsman Farms and Ralph Whitehead's Byrdcliffe, all of which were based on British prototypes. None of these had any more lasting success than William Morris's early plans to set up an artistic commune at Red House or many of the other rural workshops set up in Britain at the end of the nineteenth century.

Native Americans, such as basket and rug weaving, were featured in Stickley's *Craftsman* magazine and were much admired by American Arts and Crafts makers and thinkers (plate 1.18). Louis Comfort Tiffany (1848–1933) was an enthusiastic collector and based a range of his own metalwork and glass on traditional forms, but used in a new way (plate 1.19). Images of native people were also adopted for decoration on Rookwood pottery (see plate 11.4). This marked a real change in attitudes towards America's past and signalled the start of a confident and independent future.

Influences did not come solely from inside America, however. Britain was often visited by interested Americans as part of artistic tours of Europe. As early as 1882 H.H. Richardson (1838–86), the influential American architect in whose practice a number of prominent American Arts and Crafts architects first learned their skills, came to London. However, he spent little time on architecture but visited shops and exhibitions. He met Morris both at his London home and at the Merton Abbey workshop,[18] and became a keen advocate of Morris furnishings, using some himself but also recom-

1.20 Henry van de Velde, plate. Porcelain. Germany, 1903–4. Made by Meissen. Hessisches Landesmuseum, Darmstadt

1.21 Peter Behrens, set of drinking glasses. Gilded glass. Germany, 1902. Museum Künstlerkolonie, Darmstadt

1.22 Hans Christiansen, vase. Earthenware, painted with enamels, glazed and gilded. Germany, c.1901. Museum Künstlerkolonie, Darmstadt

Europe

The integration of ideas into new forms of enlightened, artistic, commercial production was repeated in a number of industrial areas in Europe. However, the level to which Arts and Crafts practices were wholeheartedly accepted or merely adapted was very varied.

Germany's espousal of Arts and Crafts has proved, in retrospect, to be one of the most long-lasting and influential developments of all. The setting up of many companies and workshops using both machine and hand production reflected the German perception that the British Arts and Crafts Movement was too anti-industrial and that the revival of traditional methods of manufacture was not economically viable. This did not, however, equate with a loss of quality, or a lack of desire to

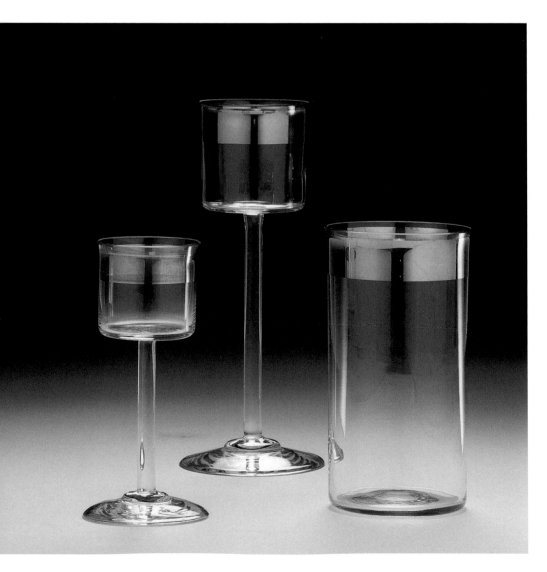

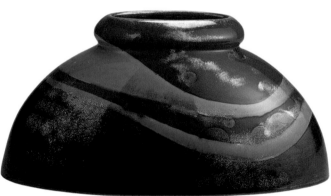

produce well-designed affordable goods for everyday use by a wide section of the public. The practical simplicity of German Arts and Crafts, and its emphasis on appropriate construction and materials were devised to meet both social and technological needs. Although many of the new workshops in Germany were founded on the model of British groups such as the Guild of Handicraft — they also aimed to elevate the status of the applied arts and shared common ideals about the use of materials and standards of craftsmanship — it was considered legitimate in Germany to use technology as a means of achieving efficient production as well as boosting local economies, so long as quality was maintained in the end product (plate 1.20).

The concept of *Gesamtkunstwerk* was seen in its most developed form at the important artists' colony at Darmstadt, Germany, founded in 1899 by Ernst

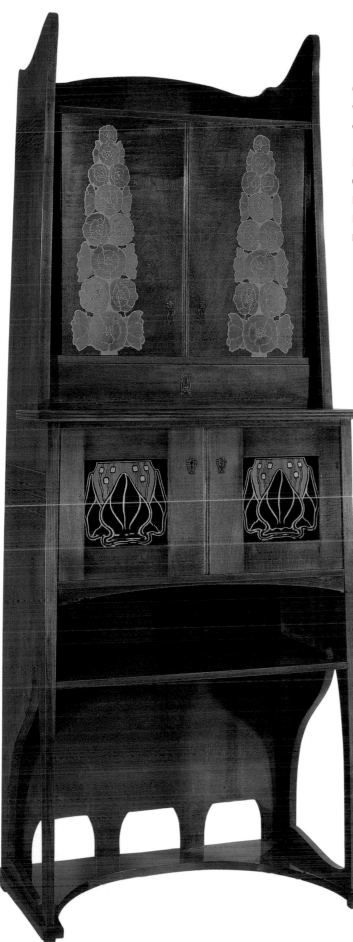

1.23 Joseph Maria Olbrich, cabinet. Maple wood inlaid with various exotic woods. Germany, 1900. Made by Hofmöbelfabrik Julius Glückert, Darmstadt. Museum Künstlerkolonie, Darmstadt

Ludwig, Grand Duke of Hesse. Ernst Ludwig wanted to raise artistic standards in local industrial products and demonstrate the relationship between the designer and the environment (plates 1.21–1.23). The houses and interiors created at Darmstadt were intended to show how design for the home could be focused and directed towards the simplest level, as a means of encouraging greater unity between art and life (plates 1.24, 1.25; see chapter 15).

Germany also proved to be an important intermediary for British Arts and Crafts ideas across Europe and into Japan. Texts by Morris and Crane were quickly available in German translations, and British developments were followed through German journals and publications. These were widely read in countries such as Sweden and Norway, which both had strong connec-

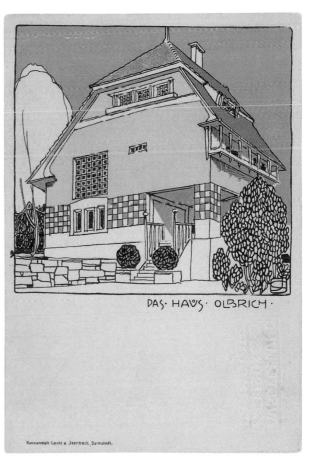

1.24 Joseph Maria Olbrich, *Das Haus Olbrich*, original design issued as a postcard. Colour lithograph on paper. Germany, 1901. Printed by Kunstanstalt Lautz & Jsenbeck, Darmstadt. Museum Künstlerkolonie, Darmstadt

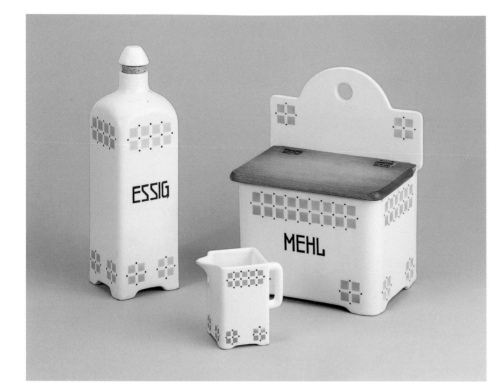

1.25 Joseph Maria Olbrich (design of the pattern), kitchenware. Glazed earthenware. Germany, c.1905. Made by Wächtersbacher Steingutfabrik. Museum Künstlerkolonie, Darmstadt

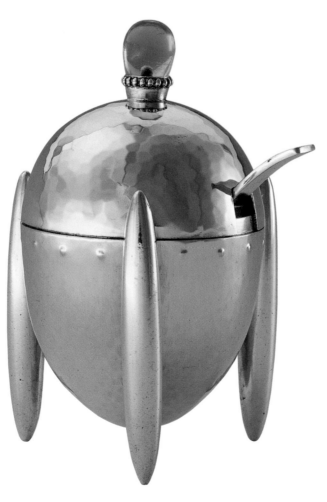

1.26 Josef Hoffmann, mustard pot with spoon. Silver, glass finial, glass inset. Austria, 1902. Made by Alexander Sturm & Co. Asenbaum Collection

tions with Germany. In Japan aspects of German Jugendstil were just one of several western influences that informed the development of its folk-craft movement in the period 1926–45. As Arts and Crafts ideas developed in Europe, Germany eventually came, in some countries, to replace Britain as the model for the successful relationship of craft and industrial production.

In Holland, where the equivalent to Arts and Crafts was known as Nieuwe Kunst, the theoretical principles of the movement were derived from German, Dutch, French and, particularly, British sources, including the writings of Walter Crane, whose presence in Europe – through publications and exhibitions – was enormously

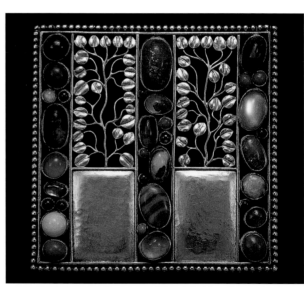

1.27 Josef Hoffmann, brooch. Silver, gold, moonstone, amethyst, lapis lazuli, opal, coral, agate, hematite, jasper, tourmaline and other semi-precious stones. Austria, designed in 1908, made in 1910. Made by Eugen Pflaumer of the Wiener Werkstätte. Asenbaum Collection

influential. Nieuwe Kunst, however, ultimately reflected the rather more autonomous position of the Netherlands, where different attitudes towards Arts and Crafts co-existed. On the one hand, the Arts and Crafts Movement in Holland reflected a search for honesty and purity in design and construction, which was played out in the discussion about the relationship between arts, crafts and industry, and the socialist ideal of art for the people. On the other, it encompassed a decorative and exotic approach to design and technique inspired by a

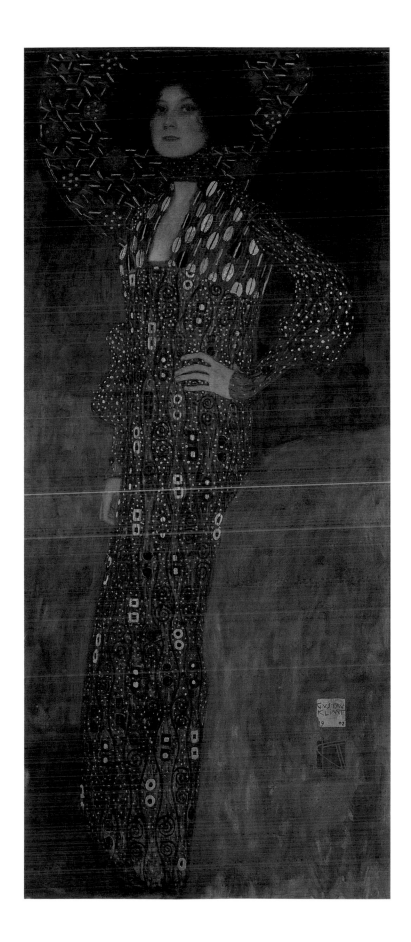

rediscovery of indigenous and colonial folk crafts (see chapter 18).

The designers and craftworkers of the Wiener Werkstatte (Viennese Workshop) in Austria applied a purist Arts and Crafts approach to their workshops, which produced only handmade goods. This was influenced to a certain extent by the visit of Josef Hoffmann (1870–1956) to C.R. Ashbee's Guild of Handicraft at Chipping Campden in 1902. The products of these two workshops were worlds apart not only in location but also in their designs, the materials they used and their commitment to the commercial world (plates 1.26, 1.27). Ironically, the greatest similarity between the two organizations lay in their reliance on wealthy clients to buy their work because of its high cost. Yet this had come about through quite different ambitions. The Guild of Handicraft wished to make one-off, hand-crafted objects that it hoped would be attractive to the limited yet ready-captured Arts and Crafts market that existed in Britain. On the other hand the Wiener Werkstätte was highly motivated in keeping abreast of cosmopolitan tastes and fashions, of which it eventually became a major leader (plates 1.28, 1.29).

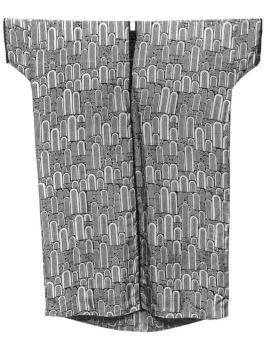

1.28 Carl Otto Czeschka, robe. Printed satin trimmed with crêpe. Austria, *c.*1913. Made for Gustav Klimt. Badisches Landesmuseum, Karlsruhe

1.29 Gustav Klimt, *Emilie Flöge*. Oil on canvas. Austria, 1902. Wien Museum

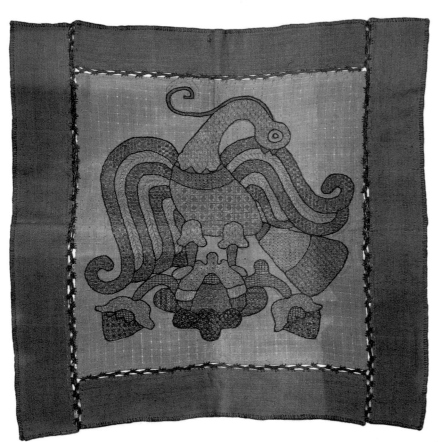

The prevalent style of Viennese design of the period — simple, geometric, decorative, luxurious — stood, both culturally and aesthetically, in marked contrast to the more traditional and vernacular forms of design that evolved in the neighbouring and politically linked countries of Central Europe. The region was characterized at this time by a complex mix of political powers and emergent pluralistic cultural and national concerns, which led in Hungary, Poland and the Czech region to the rediscovery of peasant and vernacular architecture, as well as folk art, dress, music and literature, as a means to express and preserve diverse and historically unacknowledged national identities. Likewise, in Sweden, Norway, Finland and Denmark changes in the constitution and national developments re-awakened a sense of nationalism and initiated a search for an expressive cultural identity. Russia, too, underwent a period of redefining its identity through the study of its heritage and peasantry.

Significantly, these countries had a quite different attitude to industrialization in manufacture than Britain and America. This was because large parts of Central

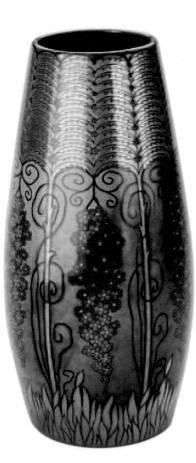

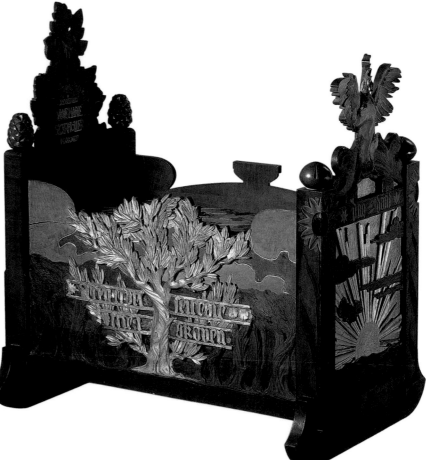

1.30 Aleksei Prokofevich Zinoviev (attr.), cover. Embroidered linen. Russia, *c.*1900. Made by the Talashkino artists' colony. Bankfield Museum, Halifax

1.31 József Rippl-Rónai, vase. Glazed earthenware with iridescent glazes. Hungary, 1898–1900. Art Institute of Chicago

1.32 Harald Slott-Møller, cradle. Carved and painted wood. Denmark, 1894. The Museum of Decorative Art, Copenhagen

Europe were dogged by social deprivation and a poor rural economy, and, like Scandinavia, saw very little industrial development compared to other parts of the continent or Britain.

The new Arts and Crafts Movement in Central Europe, Scandinavia and Russia was characterized by a revival and development of indigenous techniques and traditional patterns and forms, particularly in domestic architecture, textiles, woodcarving and ceramics (plates 1.30, 1.31). Artistic communities, such as the very early Abramtsevo workshops in Russia (1873–4) and the Gödöllő Artists' Colony in Hungary (1902), were founded on the principles of reviving traditional folk crafts and developing new national styles (see chapters 21 and 19). Museums and craft organizations were established with the express purpose of collecting and demonstrating the use of traditional crafts as models on which to base and inspire new work. Individual textile

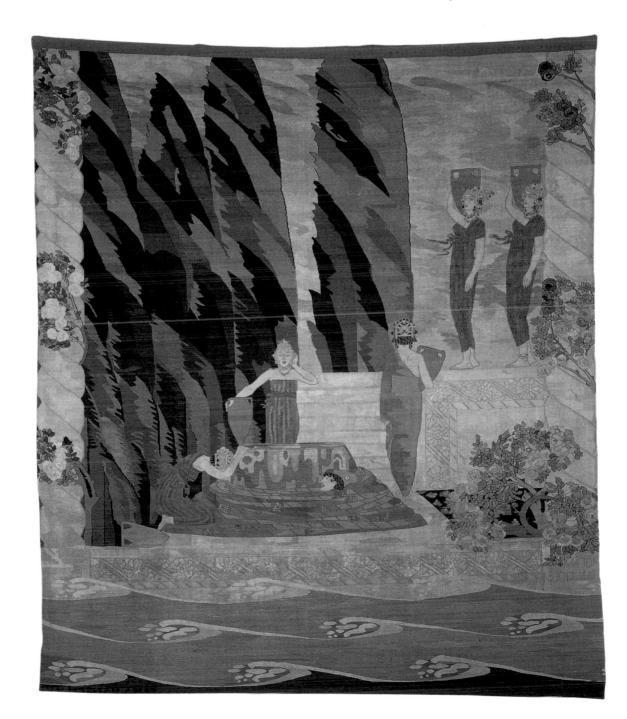

1.33 Frida Hansen, *Danaids' Jar*, tapestry. Wool. Norway, 1914. Designed and woven by Frida Hansen. Private Collection

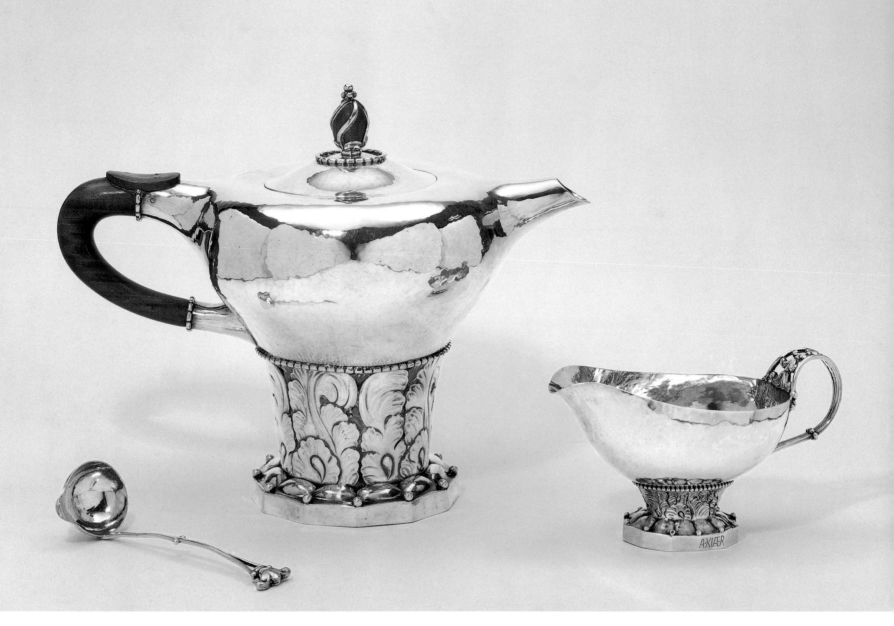

1.34 Georg Jensen, coffee set (coffee pot, ladle and creamer). Silver, rosewood. Denmark, 1909–14. V&A: M.76-78-1997

artists such as Frida Hansen (1855–1931) and Gerhard Munthe (1849–1929) combined subjects from classical mythology and folk tales (see plate 24.5), traditional colour combinations and rhythmical patterning with a modern linear style that was both ageless and innovative (plate 1.33).

In Sweden artists such as Karl and Karin Larsson fulfilled the Arts and Crafts ideal in the home that they created for their family as a 'total work of art', embodying and embellishing a rural retreat with the best of native traditions (see chapter 23). Hvitträsk, the home and studio built by architects Eliel Saarinen, Herman Gsellius and Armas Lindgren for themselves, was considered perhaps the strongest evocation of Arts and Crafts style as it developed in Finland (see chapter 22).

In Denmark in the 1890s the combination of art and pleasure in handicraft merged in the *Skønvirke* Movement, a title first used in 1907 to identify an approach

to aesthetic activity that covered everything from the pursuit of an artistic existence to painting and the design of furniture (plate 1.32). Exemplified in the silver workshops of Mögens Ballin (1871–1914) and subsequently by the silver designer Georg Jensen (1866–1935), almost an exact contemporary of C.R. Ashbee, *Skønvirke* heralded a new attitude to craftsmanship, production and design in Denmark that promoted the co-operation between designer and makers.

Ballin was a trained artist who had spent some time in Paris with Paul Gaugin and his circle. He had also planned to become a monk. A visit to the art school and workshop at a Benedictine monastery encouraged an ambition to establish his own workshop, and he was further inspired by the writings of John Ruskin and William Morris. When he finally founded his workshop in Hellerup (now a suburb of Copenhagen) in 1900, he wrote to one of the monks at the monastery:

I want to make everyday objects with a lovely form, of bronze, pewter, polished copper and other cheap metals. It is my intention to make things which even the smallest purse can afford. Art for the people and not refined art for the rich parvenus. As you see, I am building on some of the ideas of the English: William Morris, John Ruskin, and their fellows have shown me the way.[20]

Jensen encouraged artistic freedom and the development

acteristics of the leadership and patronage of the Arts and Crafts Movement in different countries. Vienna's historical and cultural history offered an explanation of its reliance on a certain class of patron. As a city it was politically more secure that other parts of Central Europe, and its confident patronage and design, which drew on the rich traditions of the city's craftsmanship, was a reflection of that stability. In Russia and elsewhere, ironically for a movement that espoused social

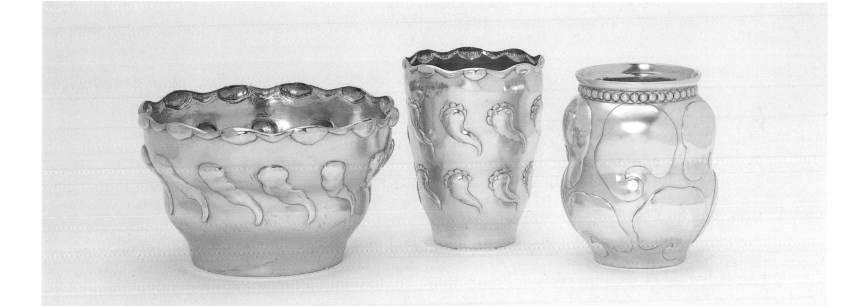

1.35 Thorvald Bindesbøll, three bowls. Silver, partly gilt. Denmark, 1899. Made by A. Michelsen.
V&A: 1612, 1613, 1614-1900

of independent work by the apprentices in his workshop, which he founded in Copenhagen in 1904. He was committed to preserving the Danish tradition of high standards in craftsmanship for his jewellery and silverwares, although, unlike Ashbee or Morris, he was not intent on promoting a social message or moral philosophy. Jensen quickly achieved international recognition for his skilfully executed and original designs, with work sold across Europe (plate 1.34). With the expansion of his workshop and production continuing well into the twentieth century, he became, arguably, the most internationally renowned of all Danish craftsmen. Indeed, the attitude to craftsmanship and production exemplified by Jensen, which flourished in Denmark through the *Skønvirke* Movement, established a legacy and approach that remains characteristic of Danish design to this day (plate 1.35).

It is also interesting to note here some further char-

reform, it was the aristocratic and wealthy classes, members of the urban elite, who were the driving force behind the development of peasant craft industries and the appropriation and promotion of the Russian vernacular to the urban consumer. In Scandinavia national styles were fashionable among the artistic and intellectual upper-middle classes, whose patronage gave rise to some lasting architectural monuments to the movement. Likewise in Japan, the search for a national identity and sense of place in the modern world was developed by an intellectual, aesthetically aware urban elite.

Japan

The Mingei (Folk Crafts) movement flourished in Japan in the period 1926 to 1945, almost forty years later than the Arts and Crafts movements in Britain, America

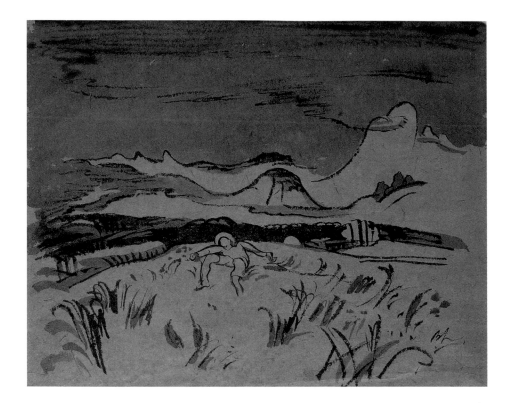

became the subject of question and debate, ideas for reform began to be expressed through various organizations and movements, including the Mingei movement, which was to prove one of the most important and influential.

What was particularly interesting about the Mingei movement is that, rather than abandoning or stripping away western ideas as a means to achieve a greater sense of national identity, it recognized that there was some value in the adoption of ideas from other cultures. Mingei was forged as a hybrid between east and west; it

1.36 Bernard Leach, *Sleep in the Hills*, drawing. Ink wash on paper. Britain, 1918. V&A: E.1199-1978

1.37 Hamada Shōji, bottle. Glazed stoneware with slip-trailed decoration on brown slip. Japan, *c.*1935. V&A: C.33-1943

and Europe, yet it was equivalent to, and in many aspects directly inspired by, these western parallels. The movement grew out of the association of Yanagi Sōetsu[21] (1889–1961) and the Japanese potters Hamada Shōji (1894–1978), Tomimoto Kenkichi (1886–1963), Kawai Kanjirō (1890–1966) and the Englishman Bernard Leach (1887–1979) (plates 1.36, 1.37). Established in 1926, the Mingei movement aimed to preserve and revitalize rural folk crafts, and through them establish a new aesthetic in modern crafts.

The time lapse between the intellectual development of the movement in the west and Japan was not, however, as great as might be initially perceived. The ideas of John Ruskin and William Morris had been known in Japan since their writings were first translated into Japanese in the 1880s, and became widely disseminated between 1910 and 1920. The modern concept of 'folk crafts' in Japan emerged at a time when rapid change was causing society to look to its past for stability and guidance, just as in Europe. The period from the 1860s saw changes in Japanese life and culture, including growth in industry and urban centres, equivalent to developments in other parts of the world where Arts and Crafts movements were manifest. Significantly, as Japan became increasingly westernized, and as this

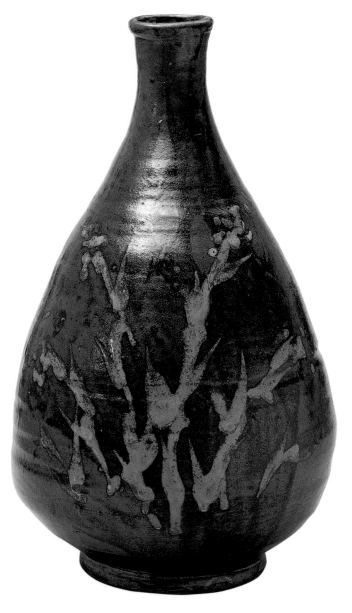

acknowledged and embraced a diverse range of both European and Asian sources and aimed to define modern life through objects and environment, combining both east and west, old and new. Indeed, the concept of the vernacular in Japan and how it could inform modern design not only included indigenous traditions, but accepted and drew upon sources as diverse as English slipware and Windsor chairs, Korean ceramics and calligraphy, Taiwanese textiles, and craft traditions from every region of Japan (plates 1.38–1.42).

The ideologies of the Mingei movement, which found beauty in everyday objects (one of the main characteristics of Arts and Crafts throughout the world), were channelled through the founding of museums, the

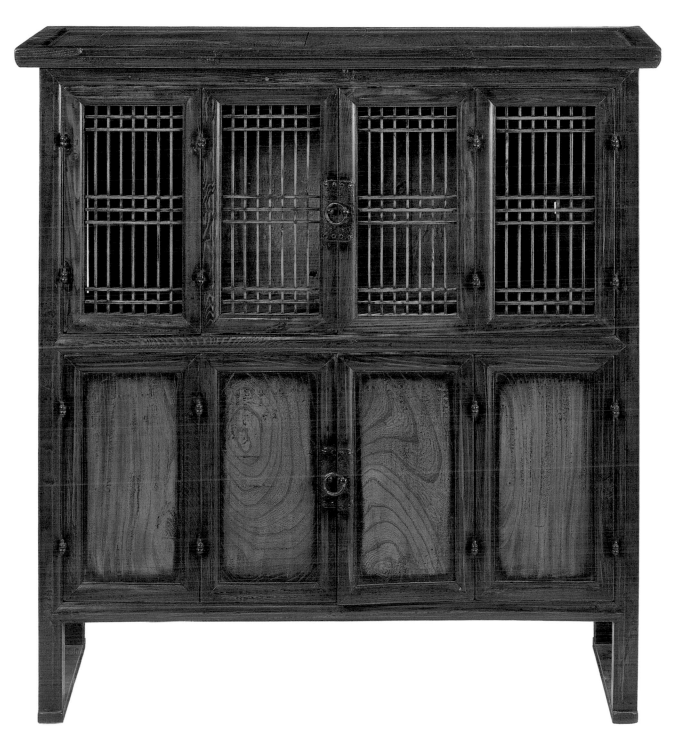

1.38 Book cabinet. Pine and zelkova wood with clear lacquer finish and iron fittings. Korea, 19th century. V&A: FE.9-1984

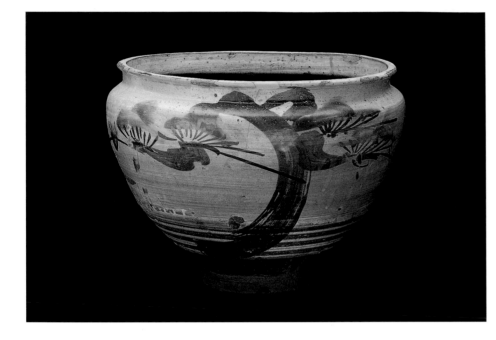

circle,[22] and laid the foundations for the development of a new European and American crafts movement based more on the development of craft techniques and the achievements of the individual. In Japan the concept of Mingei and the importance of crafts remains central to its sense of place, while elsewhere crafts also continue to thrive.

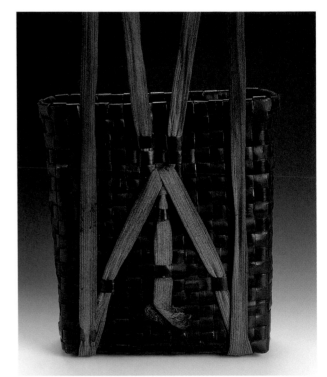

1.39 Water jar, Karatsu ware. Glazed stoneware with painting in underglaze brown and overglaze green on white slip. Japan, *c*.1650–1700. Montgomery Collection

1.40 Pannier (*shoi kago*). Split and woven cherry bark, cotton straps. Japan, late 19th–early 20th century. Montgomery Collection

1.41 Tray, Takamatsu ware. Polychrome lacquered wood. Japan, 18th century. Montgomery Collection

practices of collecting, the publication of journals and manifestos, the formation of craft associations, and through exhibition and display. Perhaps one of the most significant and extraordinary events of the Mingei movement was the presentation of the Folk Crafts Pavilion (Mingeikan), designed by Yanagi, Hamada and Kawai for the Exhibition for the Promotion of Domestic Products in Commemoration of the Enthronement of the Emperor (Gotairei Kinen Kokusan Shinkō Hakurankai), held in Ueno, Tokyo, from March to May 1928. This comprised a series of interiors for the middle classes, designed to demonstrate how traditional crafts could be integrated into modern living, and how western modes of living could be combined with Japanese (see chapter 27).

The group of individual craft makers associated with Yanagi, joined by the lacquer-worker Kuroda Tatsuaki (1904–82), the print-maker Munakata Shikō (1903–75) and the textile-artist Serizawa Keisuke (1895–1984), were to prove enormously influential in the perception of crafts in the twentieth century (plate 1.43). The experiences of Hamada and Leach in St Ives, Cornwall, and at the Arts and Crafts community in Ditchling, Sussex, of a form of cultured living – as perceived by William Morris for Red House but never realized – confirmed them in their pursuit of a way of life and work both healthy and natural. Their return to the UK after 1952 brought the Arts and Crafts Movement full

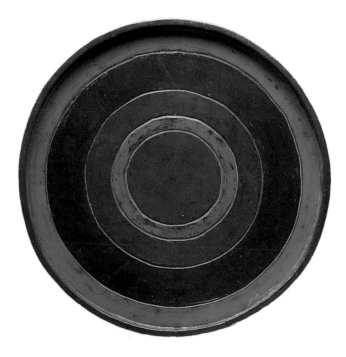

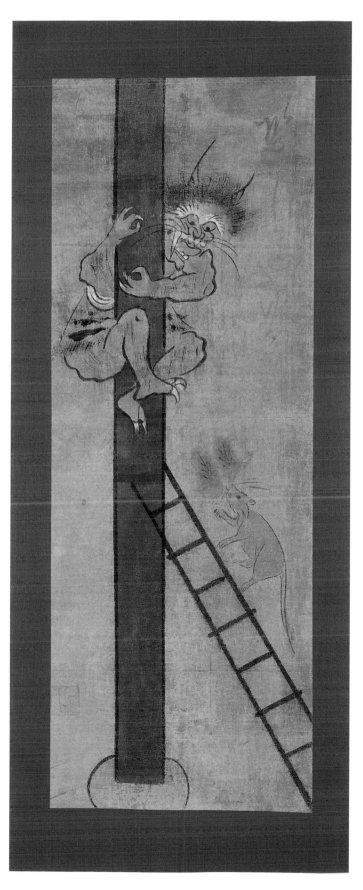

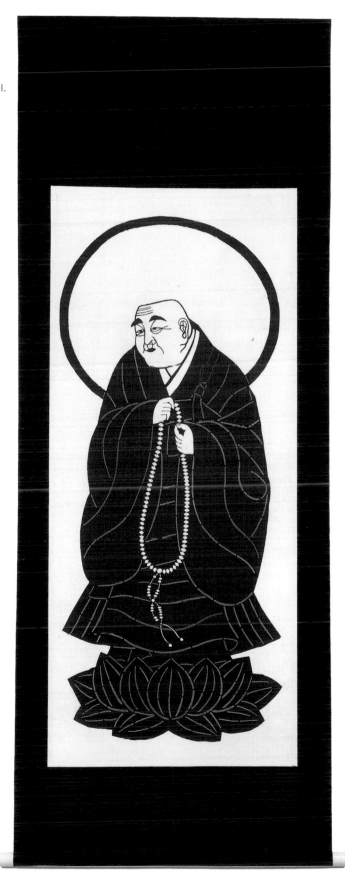

1.42 Ōtsu-e painting, *Demon Being Chased up a Pillar*, hanging scroll. Ink and colours on paper. Japan, 18th century. Montgomery Collection

1.43 Serizawa Keisuke, *The Buddhist Priest Hōnen Shōnin*, hanging scroll. Stencil-dyed silk, ivory rollers. Japan, 1942. V&A: FE.22-1985

PART ONE